THE MAGNIFICENT MONSTER COLORING BOOK FOR GROWN UPS!

ILLUSTRATED BY TORIAN DEDMON, SR.

WARNING!
SOME ILLUSTRATIONS IN THIS COLORING BOOK MAY NOT BE SUITABLE FOR CHILDREN UNDER 18. PARENTAL DISCRETION IS ADVISED!

ALL OF THE IMAGES ARE PRINTED ON SINGLE-SIDED PAPER. YOU CAN USE CRAYONS, COLOR PENCILS, FELT-TIP PENS AND MARKERS. WHEN USING FELT-TIP PENS AND MARKERS, PLACE A SHEET OF PAPER BETWEEN IMAGES TO AVOID BLEED-THROUGH.

1st Edition First Published 2016
Copyright 2016 Torian Dedmon, Sr. for TJD Creative Media Co. All rights reserved. No part of this book may be reproduced or transmitted in any form or by any means, electronic or mechanical, including photocopying, recording or by any information storage and retrieval system, without written permission from the author.

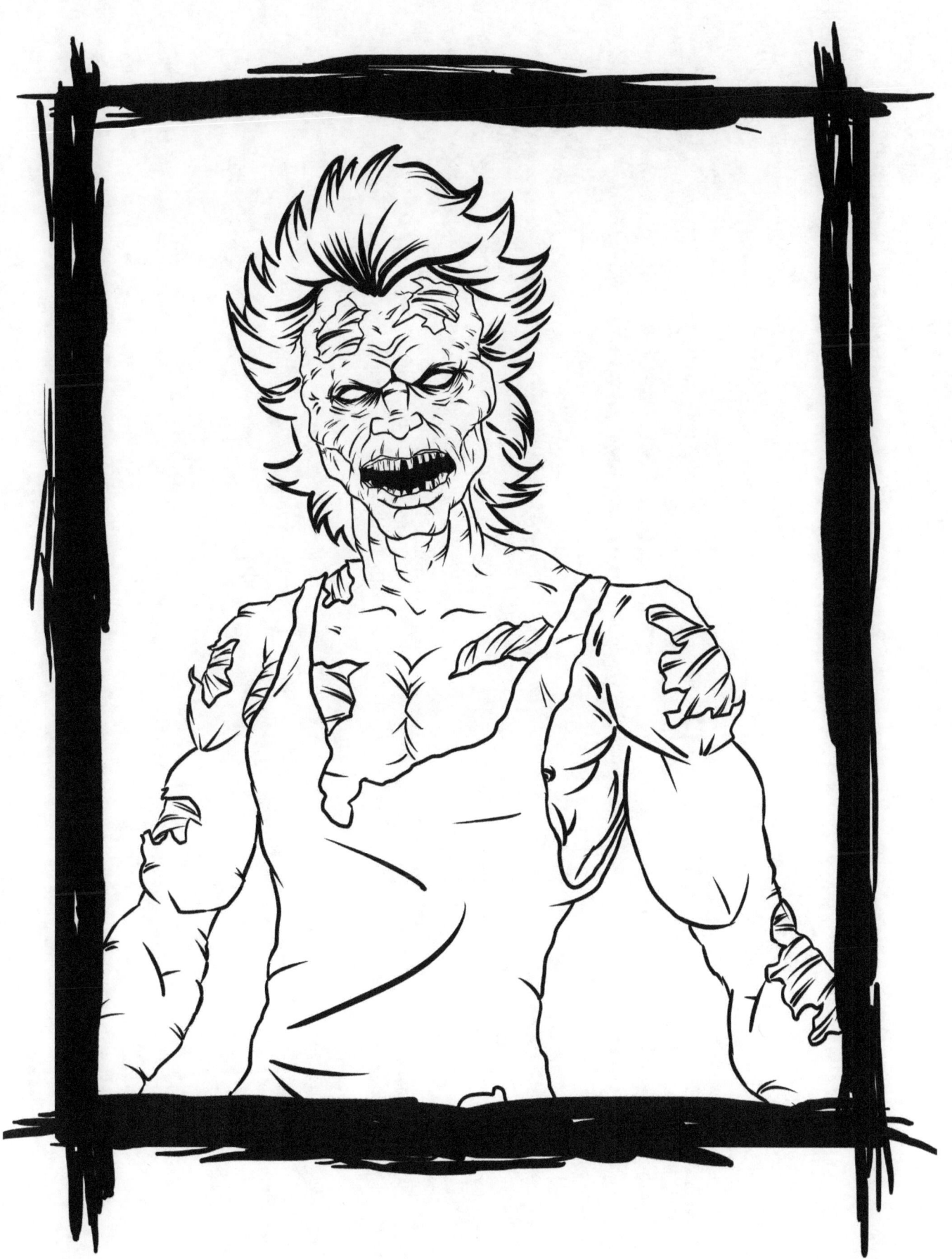

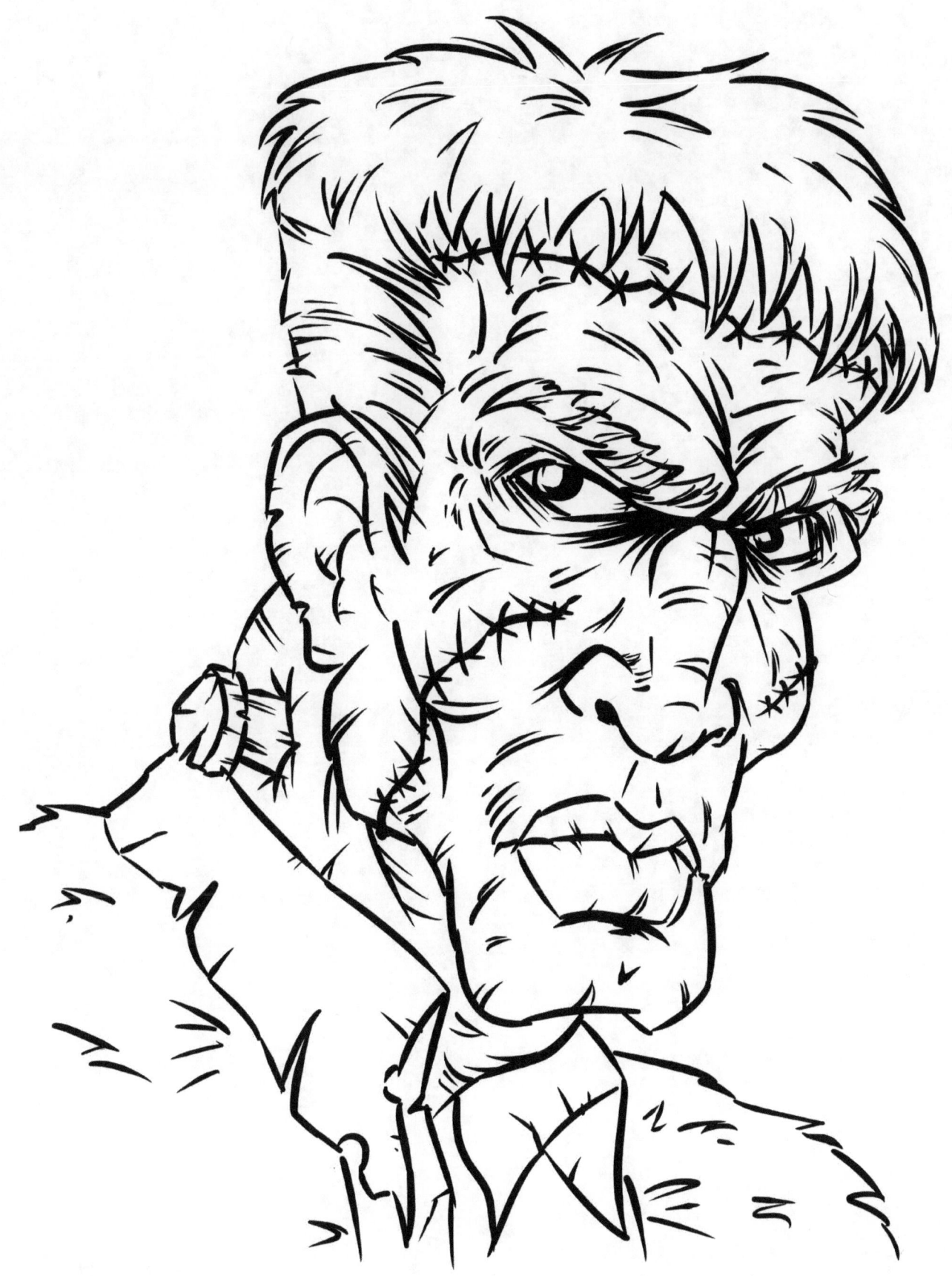

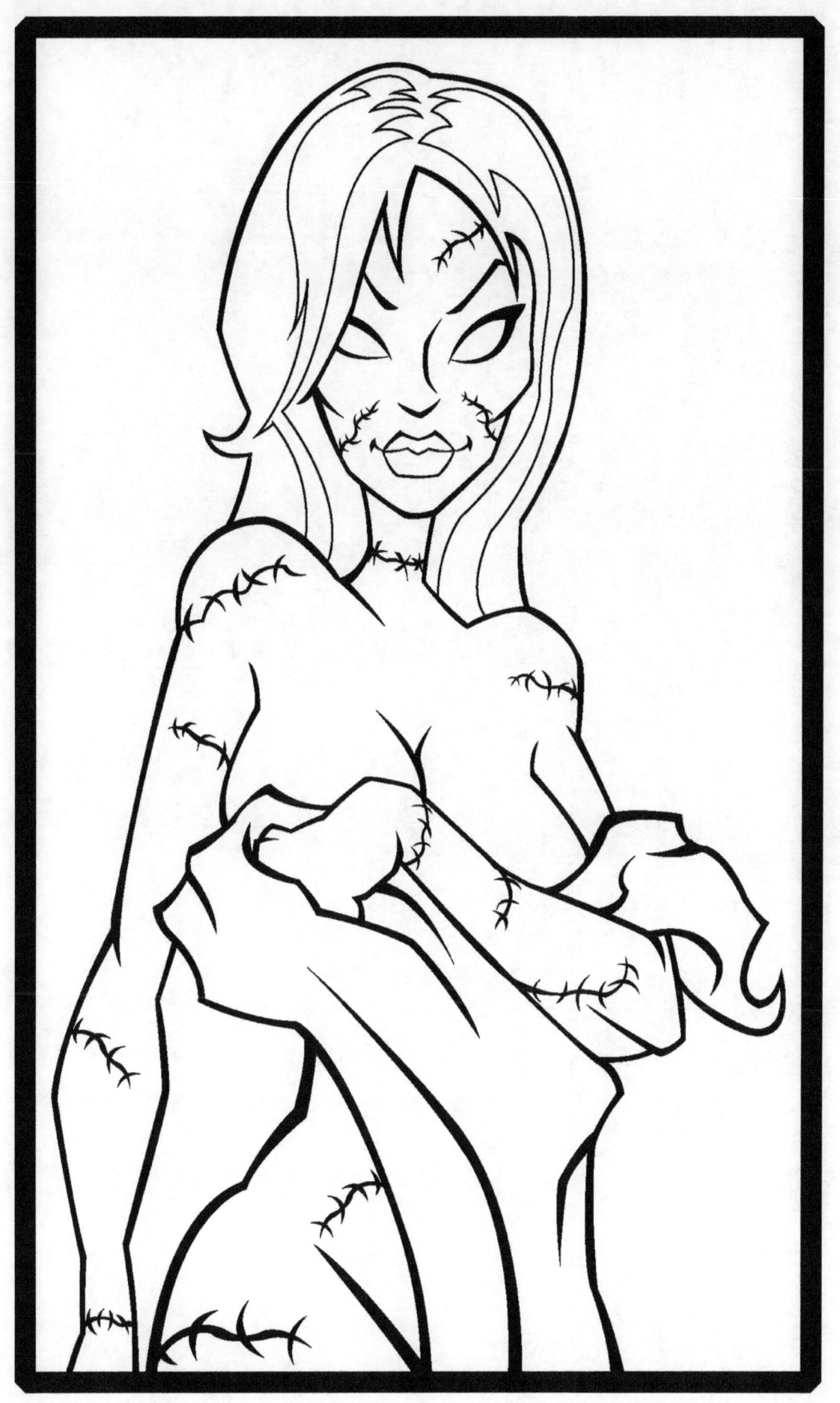

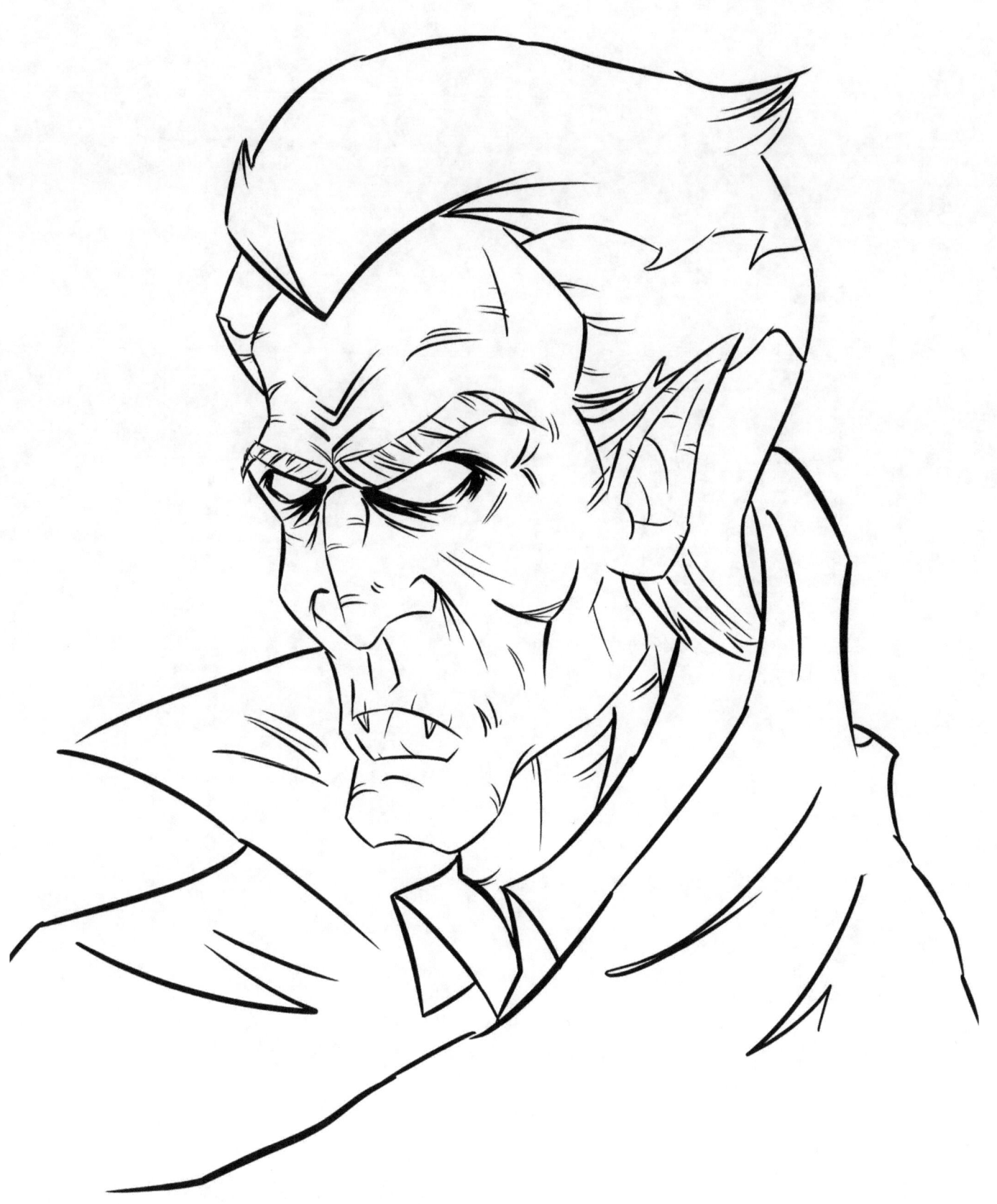

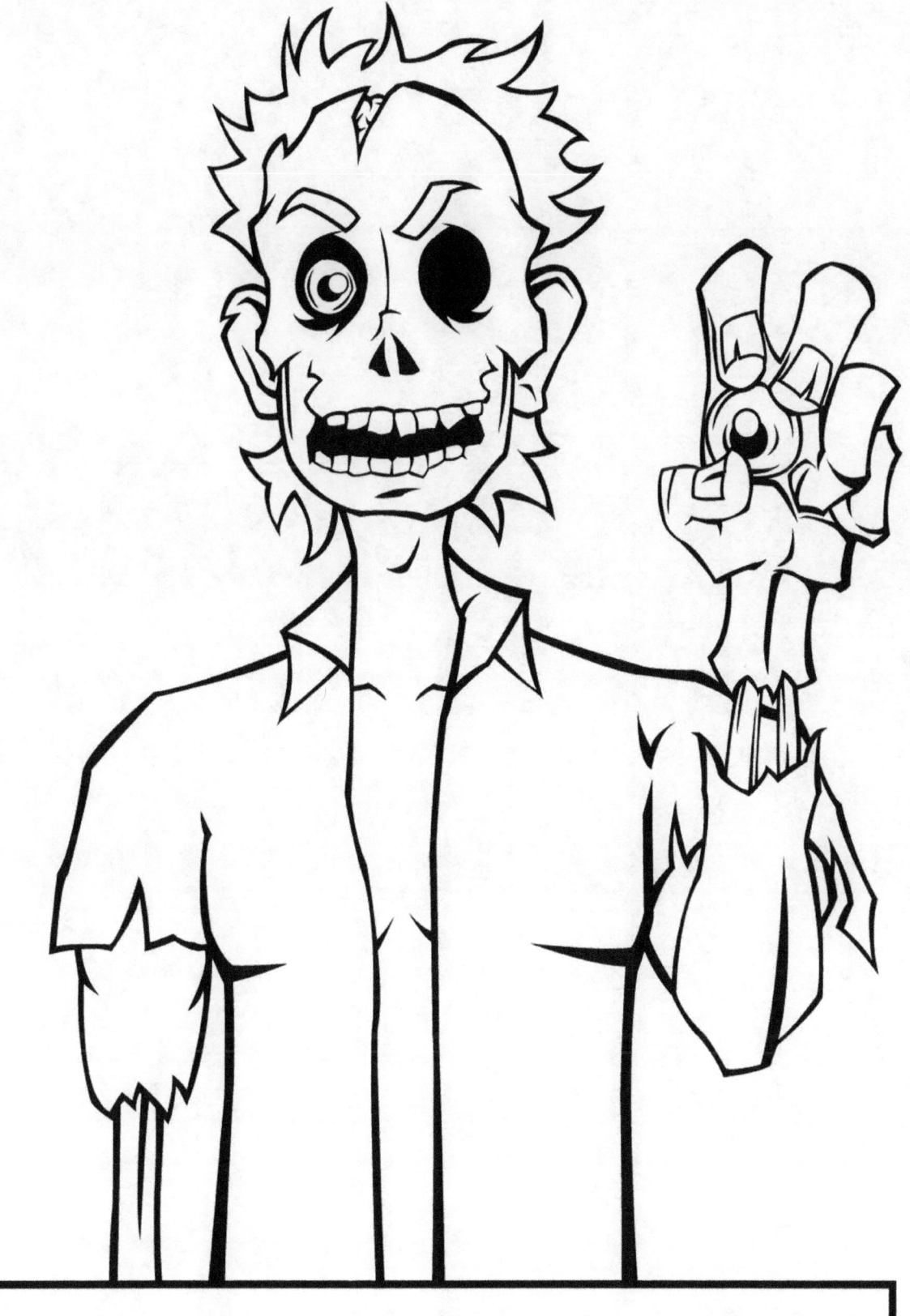

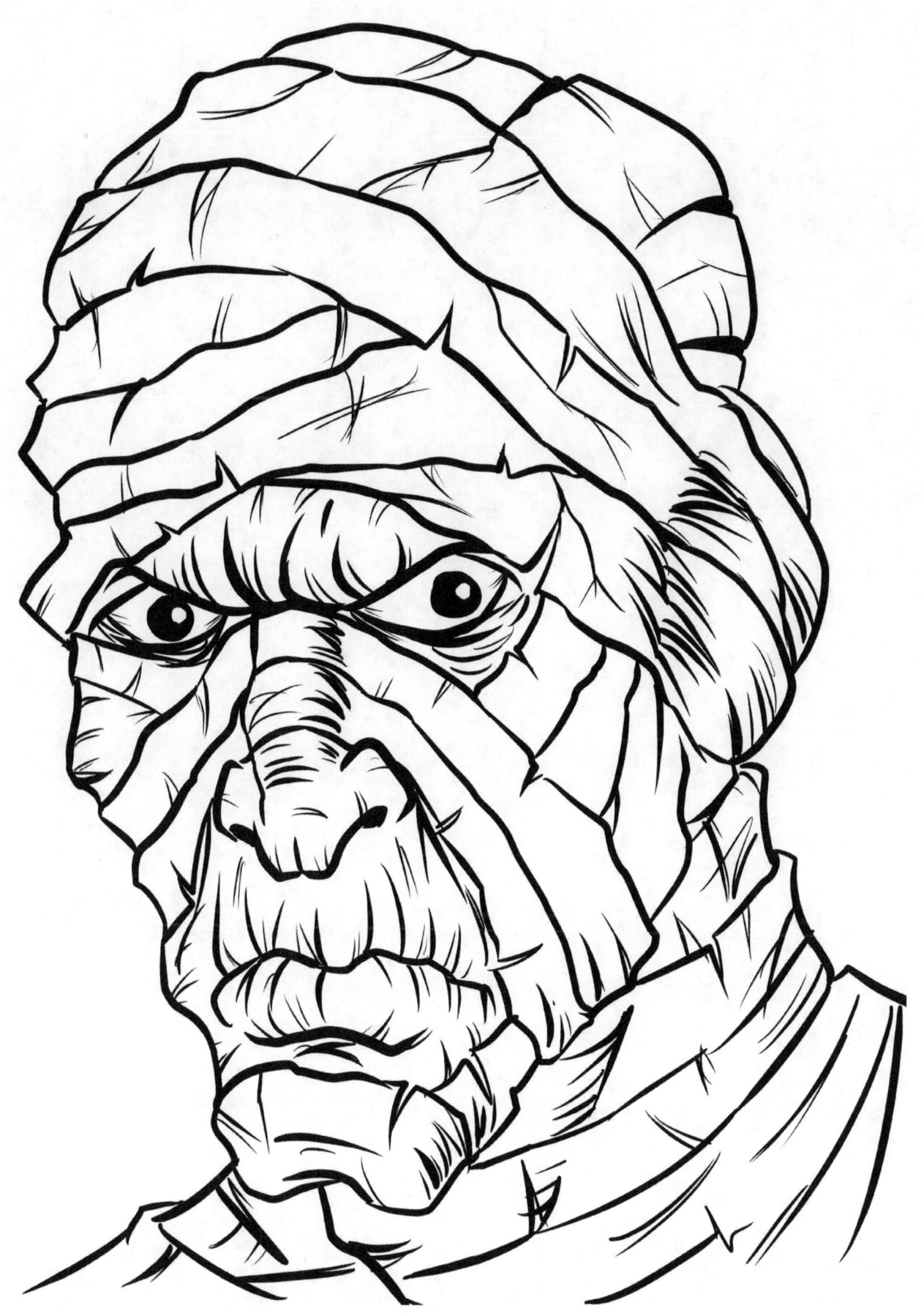

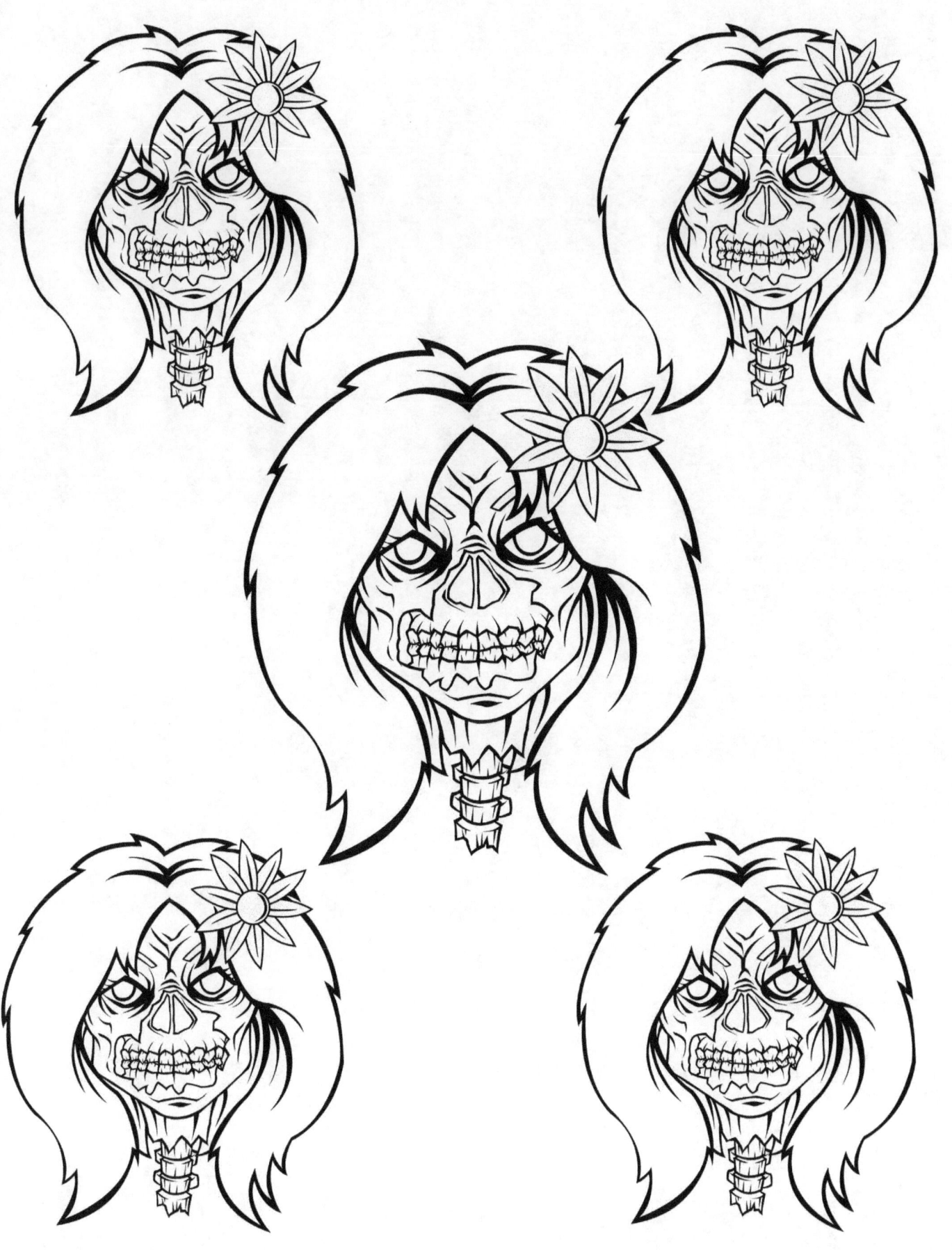

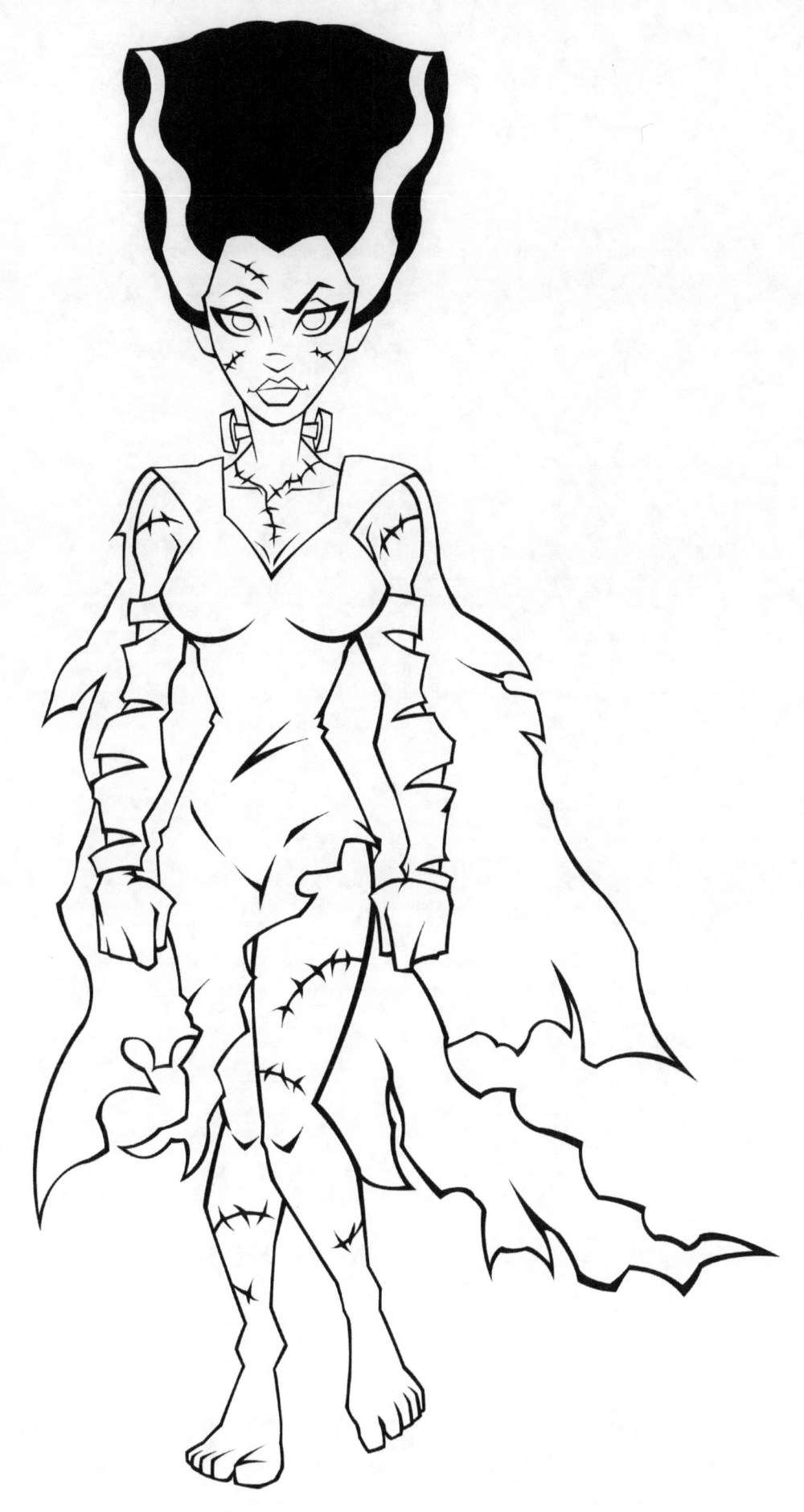

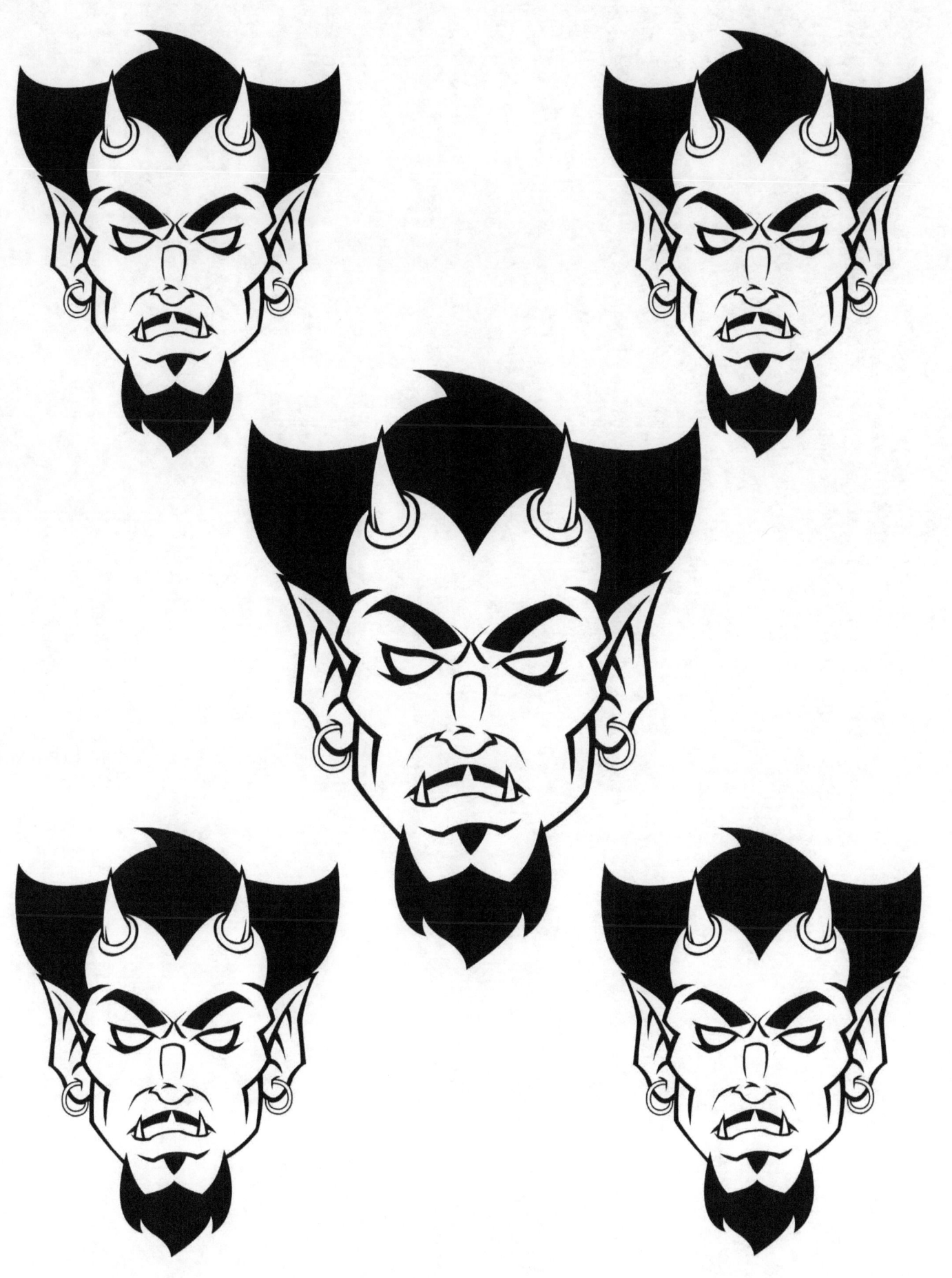

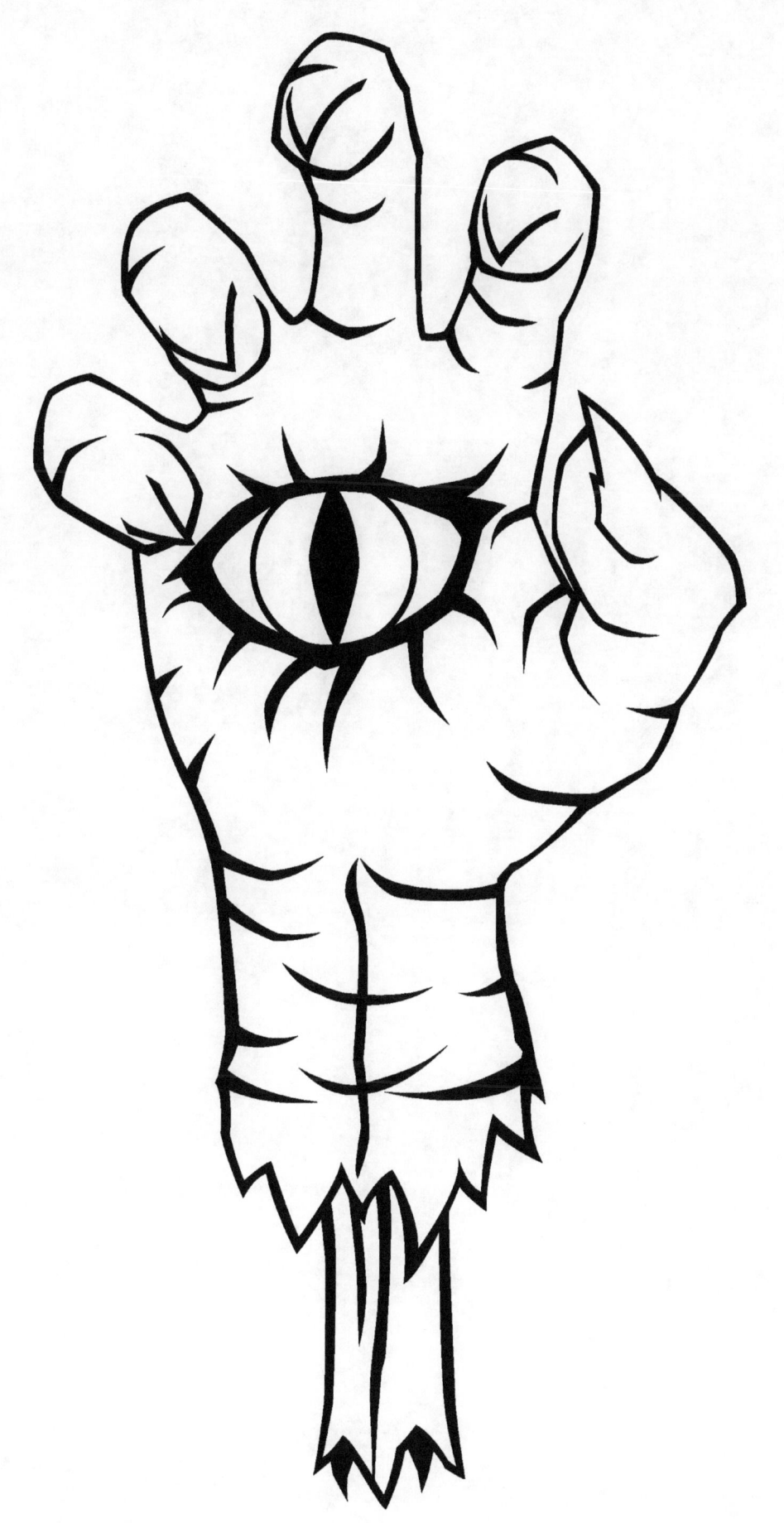

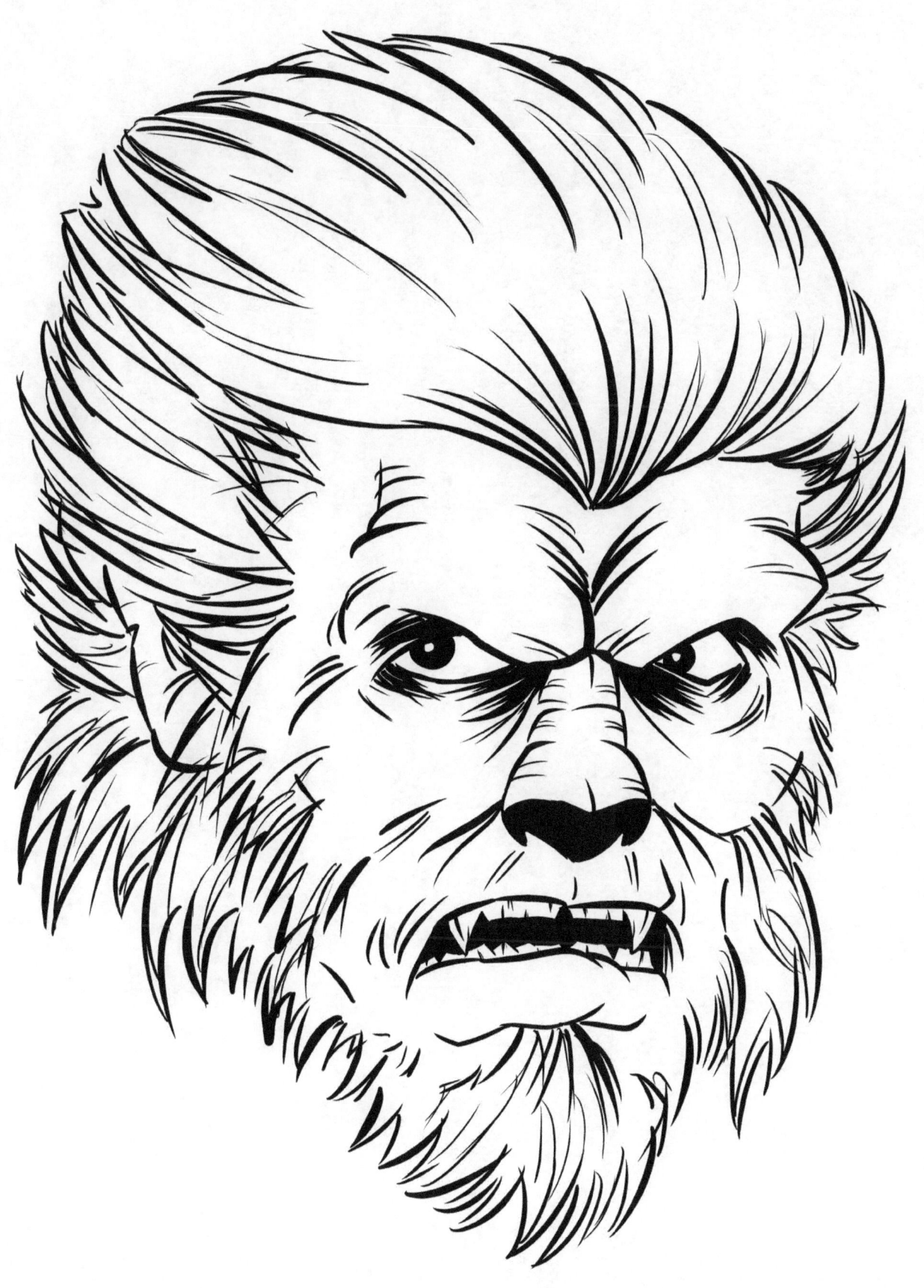

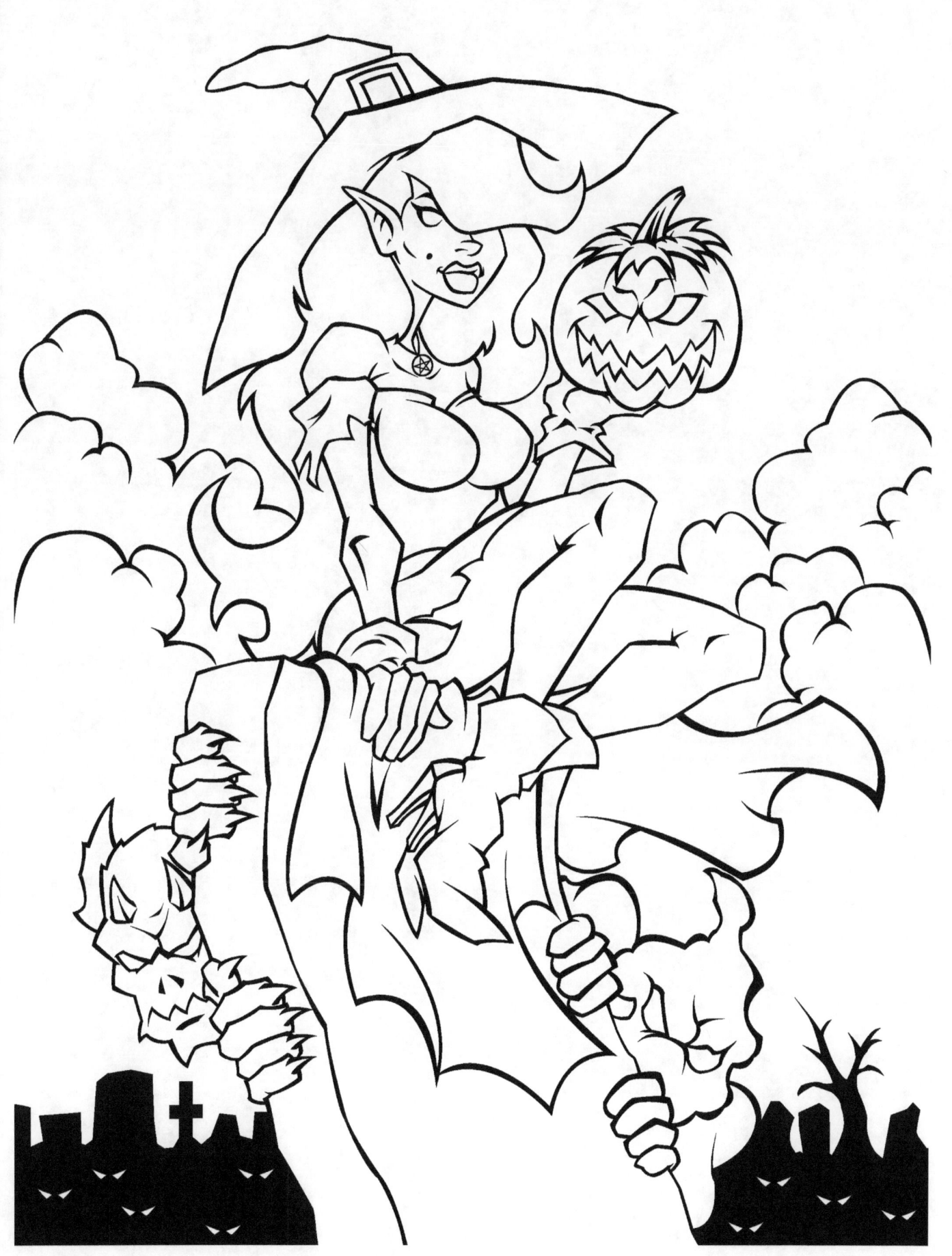

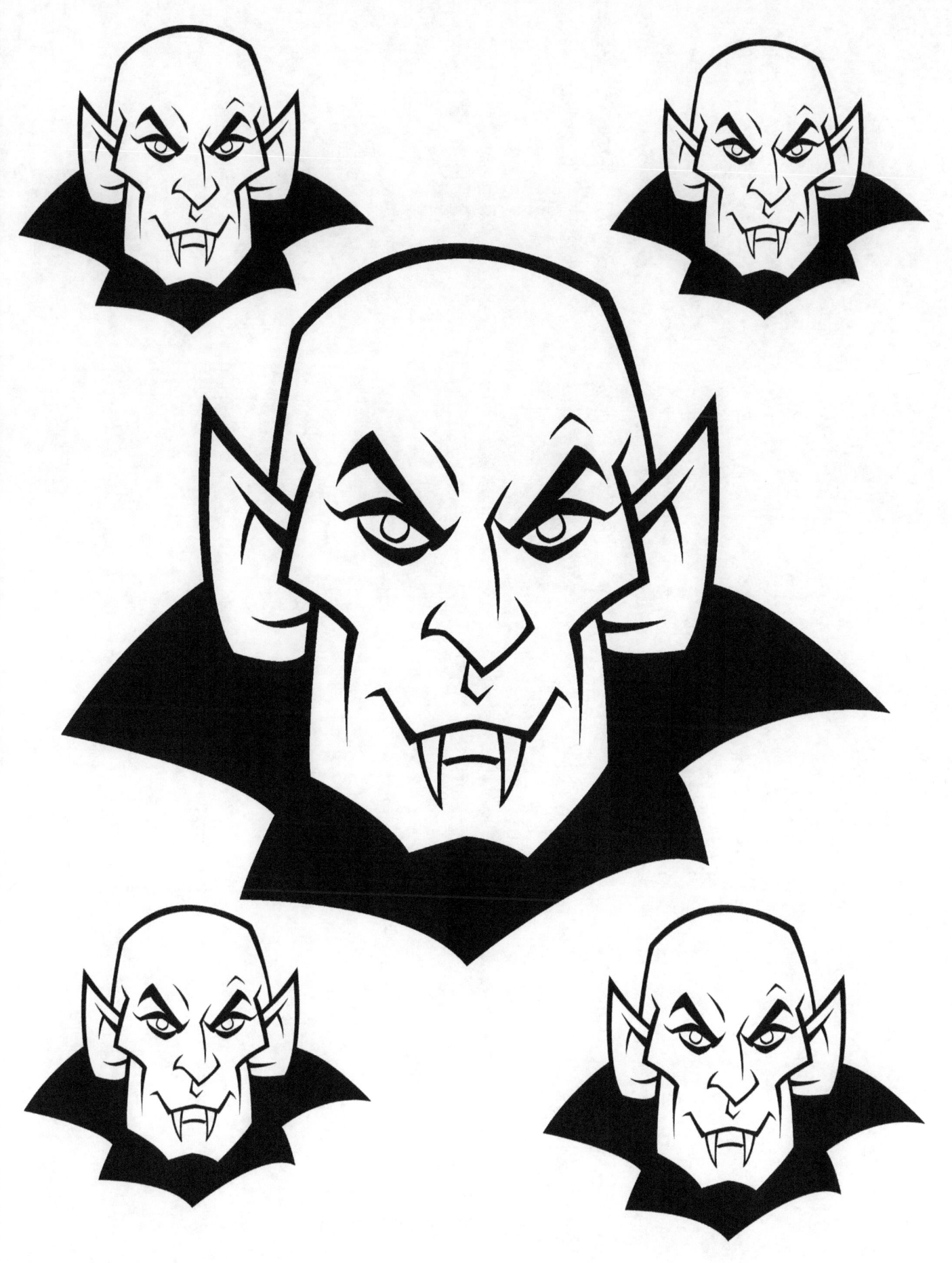

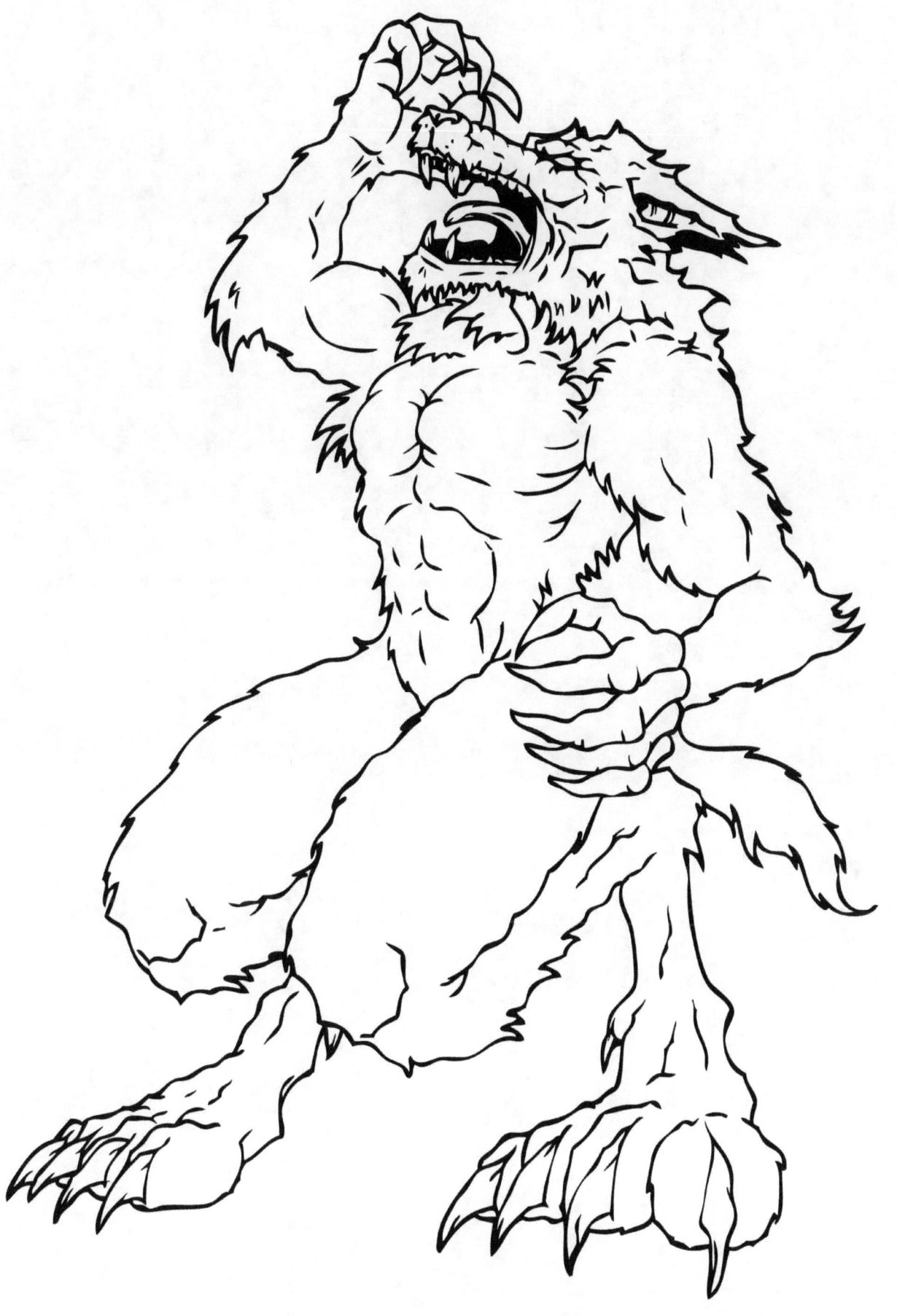

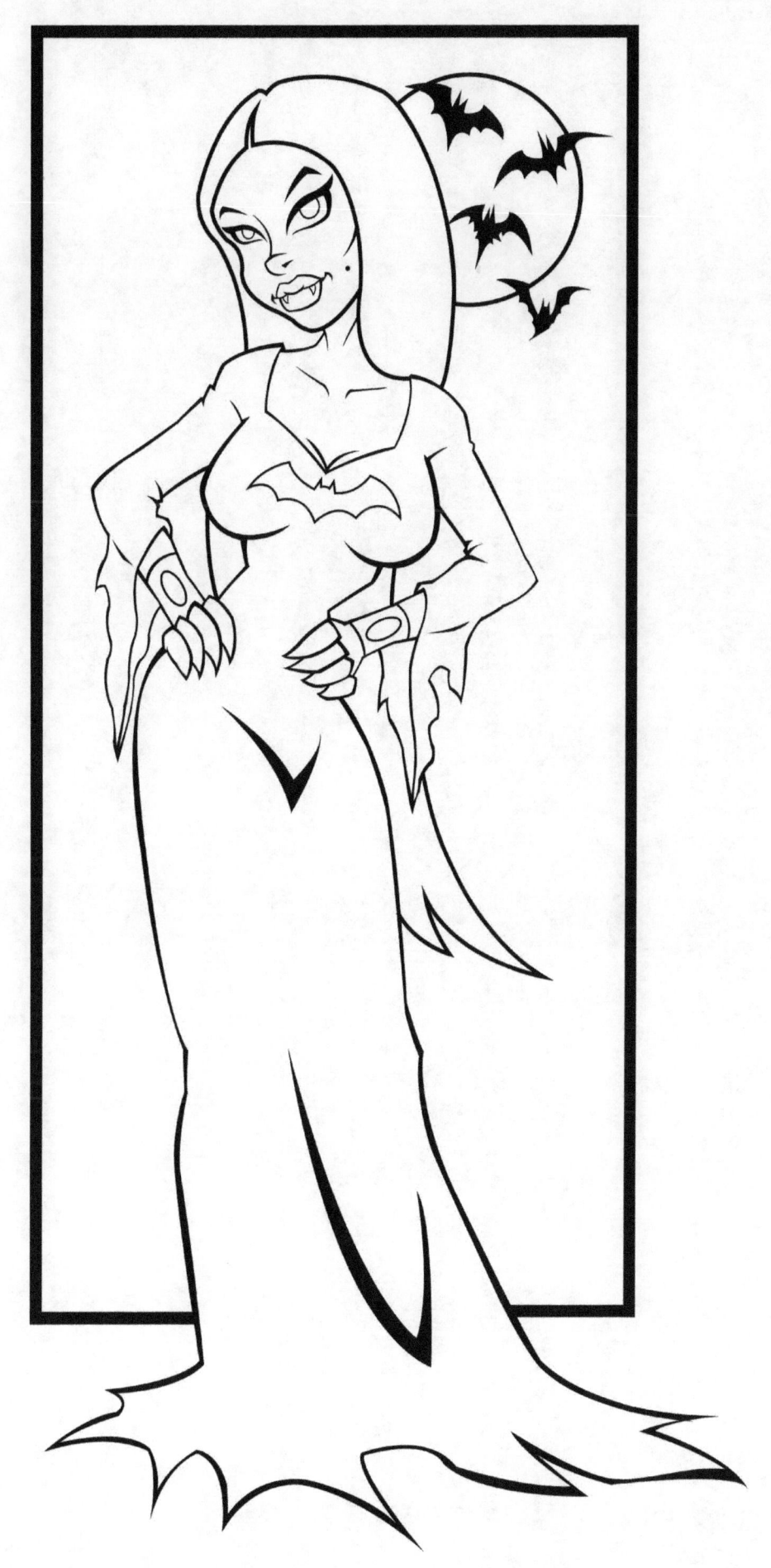

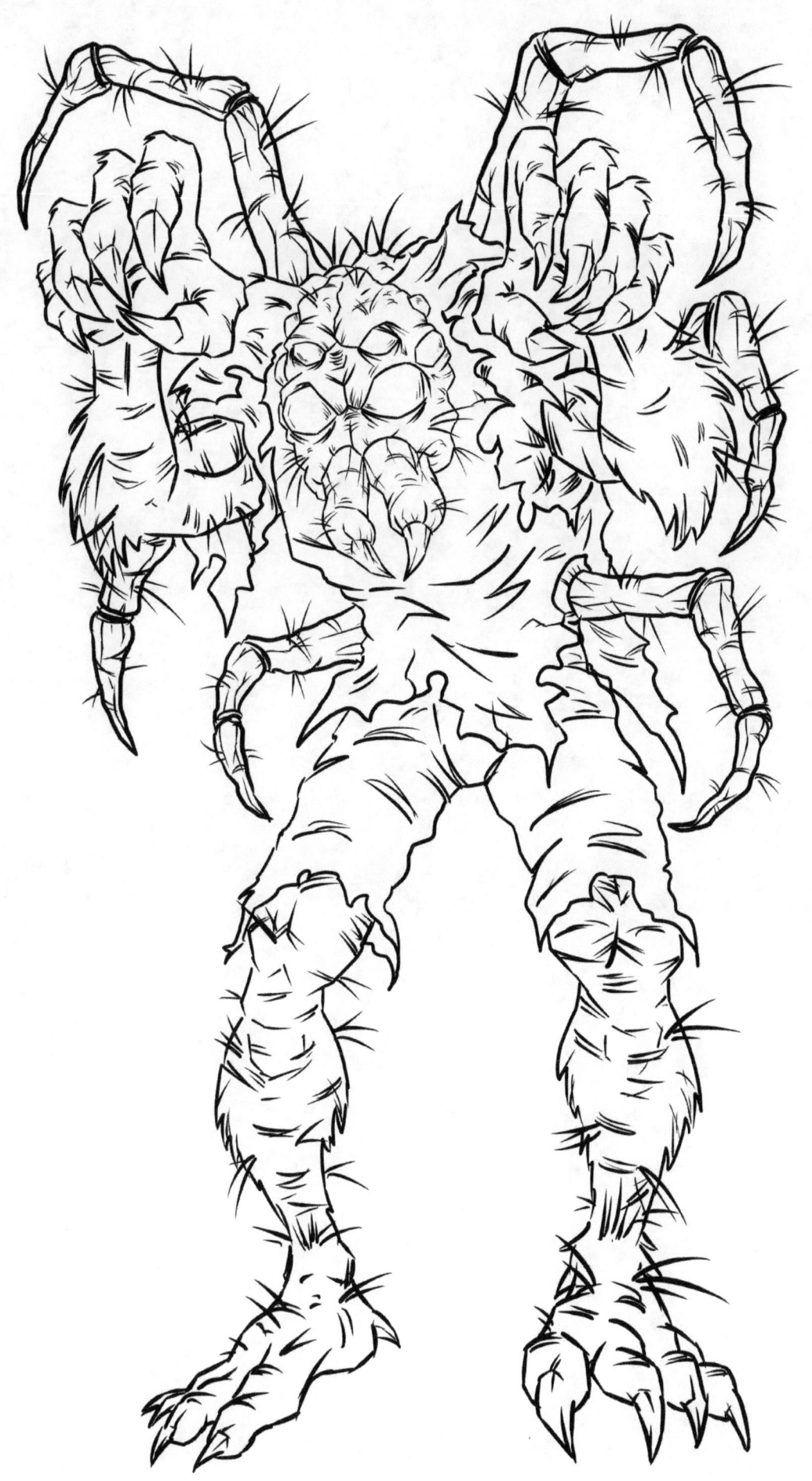

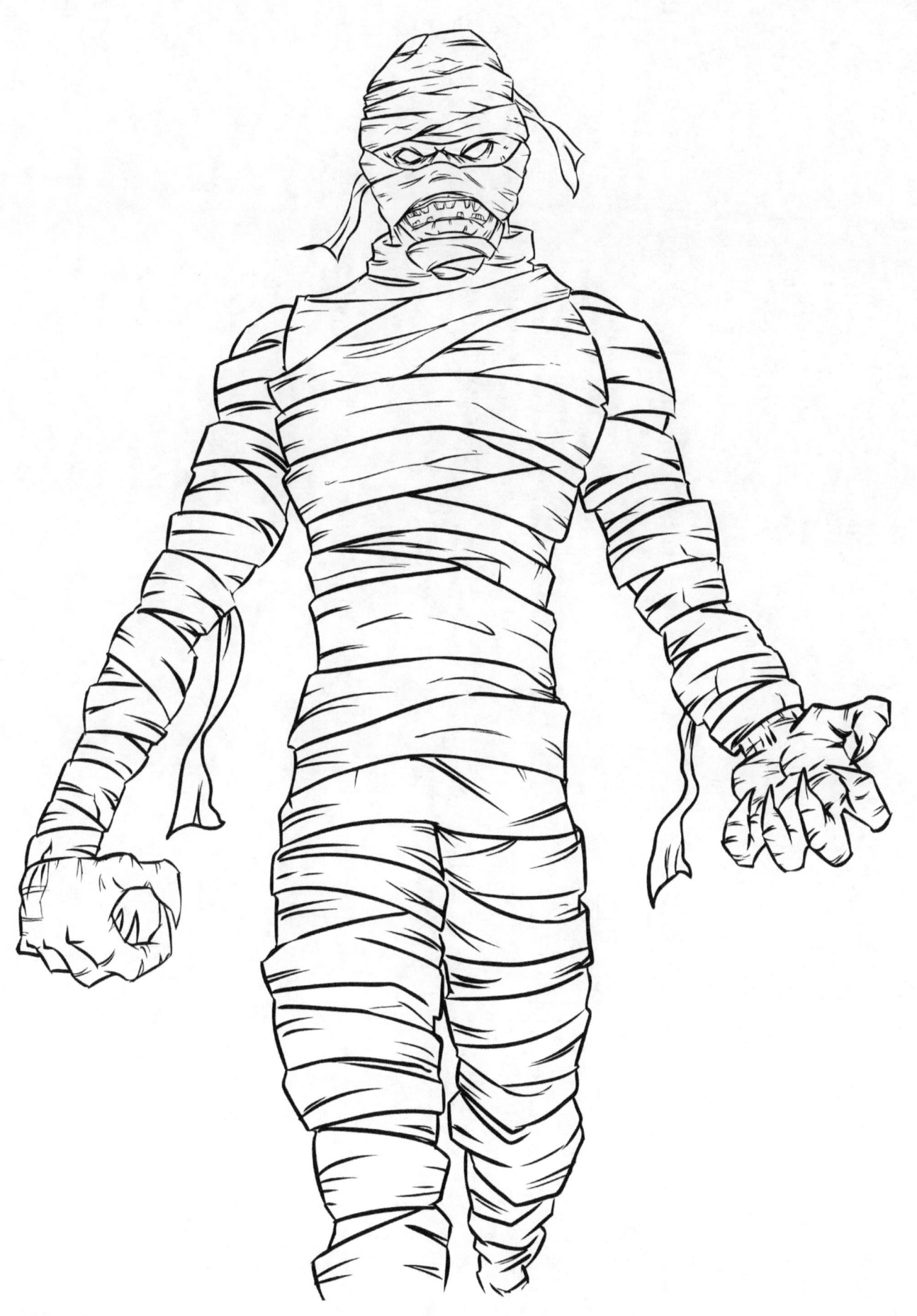

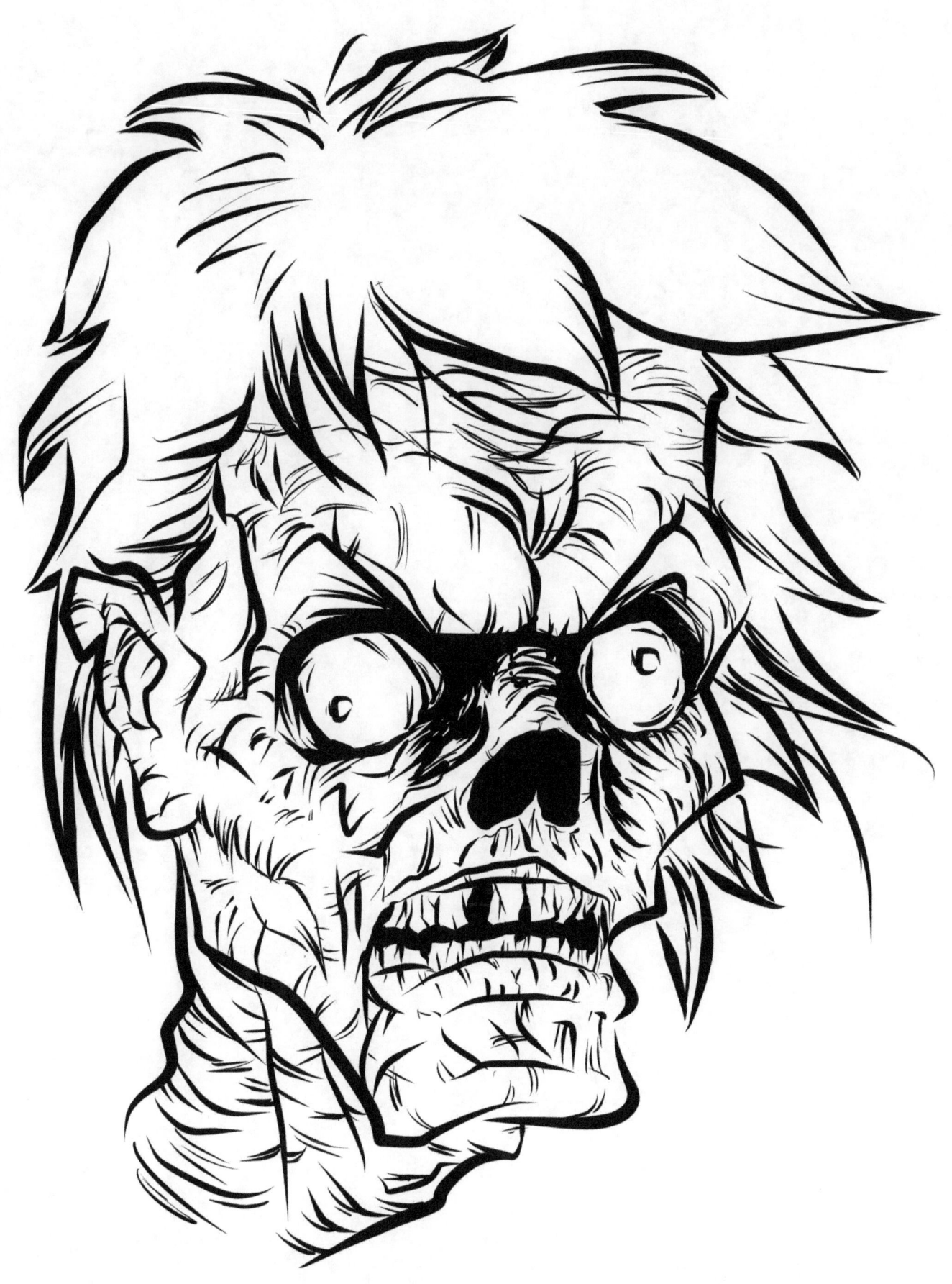

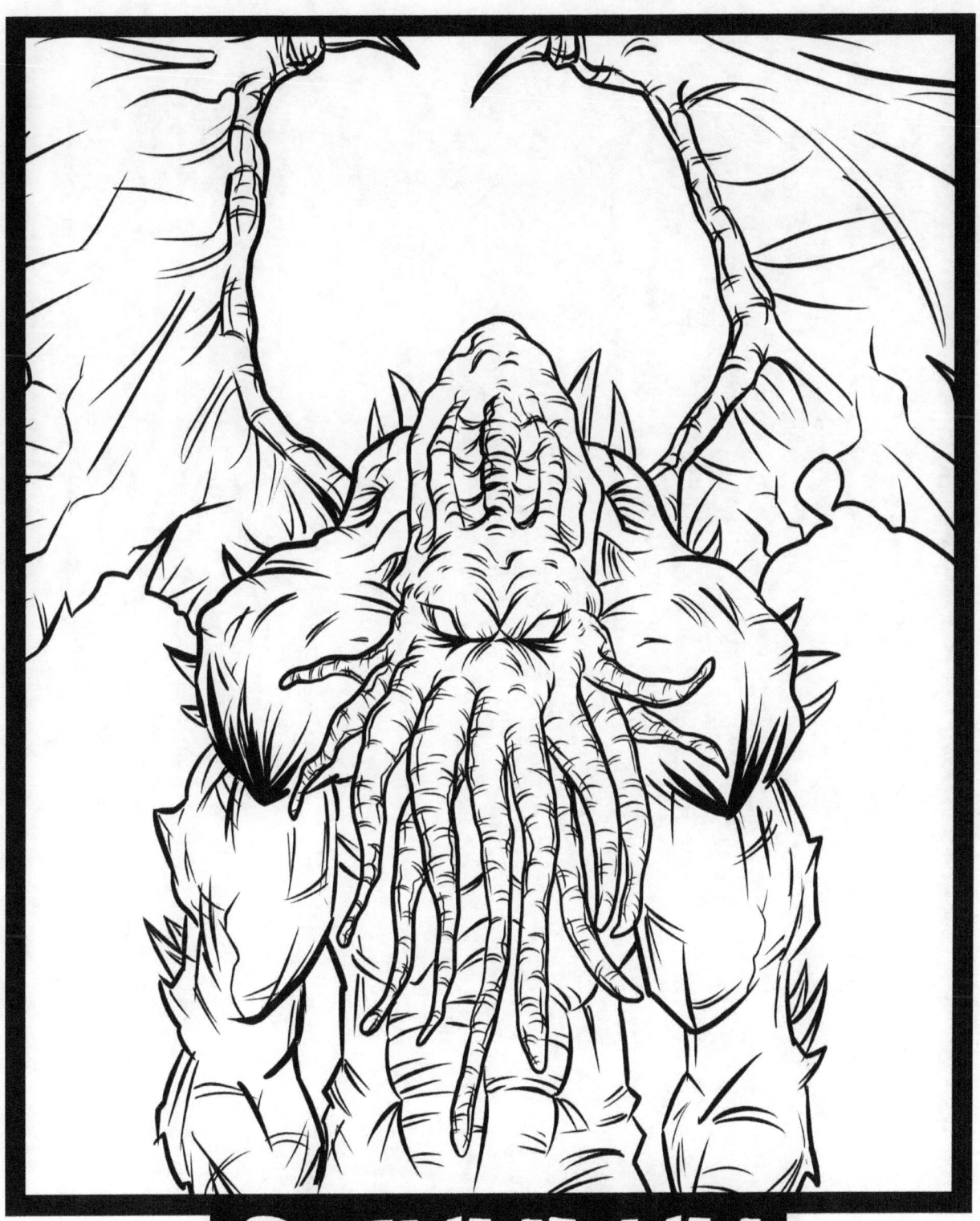

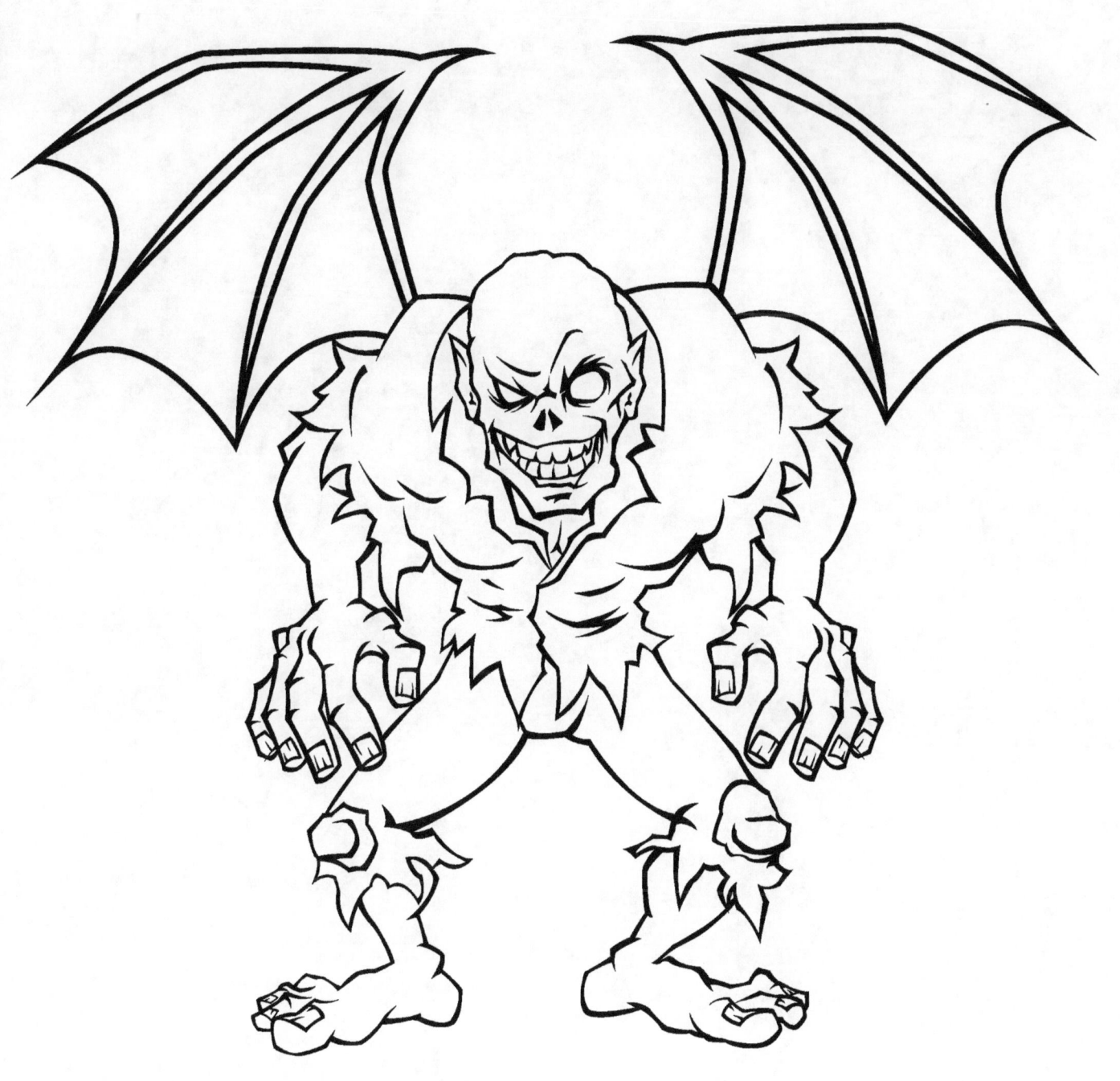

TORIAN DEDMON, SR. IS AN ILLUSTRATOR AND AUTHOR RESIDING IN CA. HE TAUGHT HIMSELF TO DRAW AS A CHILD AND HAS BEEN CREATING ART EVER SINCE! HIS INFLUENCES ARE COMIC BOOKS, FANTASY, HORROR AND SCIENCE FICTION.

CONTACT INFO:
WWW.TJDILLUSTRATION.COM
EMAIL:TORIAN@TJDILLUSTRATION.COM
WWW.TJDADULTCOLORINGBOOKS.COM
EMAIL:INFO@TJDADULTCOLORINGBOOKS.COM

2016 TJD CREATIVE MEDIA CO.

www.ingramcontent.com/pod-product-compliance
Lightning Source LLC
Chambersburg PA
CBHW08061419O526
45169CB00007B/3006